T0130195

Visions and Voices

Visions and Voices

Drawings and Poems

Paul Weingarten

VISIONS AND VOICES
DRAWINGS AND POEMS

Photography and layout by Dylan Weingarten.

Front cover self-portrait and back cover woman by Paul Weingarten."

iUniverse books may be ordered through booksellers or by contacting:

iUniverse
1663 Liberty Drive
Bloomington, IN 47403
www.iuniverse.com
1-800-Authors (1-800-288-4677)

Because of the dynamic nature of the Internet, any web addresses or links contained in this book may have changed since publication and may no longer be valid. The views expressed in this work are solely those of the author and do not necessarily reflect the views of the publisher, and the publisher hereby disclaims any responsibility for them.

Any people depicted in stock imagery provided by Thinkstock are models, and such images are being used for illustrative purposes only. Certain stock imagery © Thinkstock.

ISBN: 978-1-4917-8200-2 (sc)
ISBN: 978-1-4917-8201-9 (e)

Library of Congress Control Number: 2015920084

Print information available on the last page.

iUniverse rev. date: 03/23/2016

Contents

People

Landscapes and Cityscapes

Introduction

Art is a result derived from a process that emanates from sensation. The deeper, more basic, more intensely felt the sensation, the greater the opportunity to see, clarify, and transfer it to canvas or paper. Of all sensations, the one most important in this process is pain. Whether it be melancholy, anxiety, anger, desire, longing, or emptiness, pain impels us to seek release and ultimately solace through communication. It creates the need to turn inward and center on oneself and inspires the will to see what is felt so deeply. Pain orients our external realities to fit our internal states, thus the creation of personal vision.

Pleasures alone seldom provide such fertile soil. Sensuality, humor, and so forth, serve art as contrast or relief. The most profound form of artistic identification will encompass compassion and awe. It is an honesty and humility that sees the life struggle through an identification with it while still maintaining the glow of life's mystical, incomprehensible, yet very real glory. All of this is derived from the lonely contemplation of pain.

The summary of my career to this point is to have arrived at an understanding of my task heretofore—to externalize, with simple clarity, the internal realities that touch us all. Both traditional and revolutionary is the endeavor that seeks to rekindle in myself the light that glows from humanity throughout all of history and the spark of individuality specific to a time and place. Nature and the life that is in the great paintings of each and every age hold the key to the union of these two lights and thus to my intention as an artist.

VOICES

God's Will

As his life was not his to live
But to make all the choral angels cry,
That with the cutting by a scythe
Or the blinding of an eye,
That such devotion You require
The humble willingly submit
And of the torment never tire,
Such cruelty this You would permit.
Yet, silent as his empty life,
Save for his neglect and pain,
At last heaven's glorious knife
Removed him from his frame.
So in death all that he required
Was a respite for the tired.

In Gratitude

The grace of dreams is stolen by
A burst of bombast upon the dawn,
The tender mercy of our calm by
The boisterous glory of the morn.
Our hearts are distant when at rest,
Our souls not put to the test
As when we arise to pray
In grateful praise of the day.

In Memory of the Painter Barnard Chaet

Fruits fall inevitably from their tree
When they are beyond their season.
 Though a delicious memory
So abundant, so constant, we
Hardly notice the slow embrace the
Earth offers to their decay.
Oh, how many seeds were planted on that day.

With ripe succulence sequestered
 Beneath its skin,
A man's talents, his vision,
Are tied oh so tenaciously
 To the limb
And from the trunk that grips the earth
 To all humanity.

And when the time has come for the fruit to fall
And lay still with all
From whom the earth had grown enriched,
Our seeds will spread across the land
And blossom from the nourishment
Of a solitary man.

On the Death of Father Zogby

I

Shall we walk along the holy streets of Jerusalem?
Hear the gentle clatter of cobbled feet
As in the hallways of one's cerebellum?
Will we meander in foreign lands
With caravans upon the sands
Or horses in the snow?
Are we not dreamers whose only distant shore
Is in rummaging through hearts, jiggling
 the key to a forgotten door?
He was a traveler who tasted lamb
And saw the road to martyrdom.
He held his cancerous fists in mine.
I saw the precipice, the edge of time.
But who was there to know
That I had seen the torch-lit horror of long ago?
And who else was there to see the descent that night
 was deep and far
Like a falling angel or a shooting star?
But how can this be?
The ground so ravenous and yet so holy.
Can we ever understand
When a life is at hand?

II

A long shadow lingers from the strong
Full moon barren and aloof cools
The melancholy earth with a silent song
And lays liquid golden in a pool.
Beyond heaven, bent eyes caress the stars, tear
Stained and splintered in the deep hollow
Of a heart emptied year by year.
The night sky silhouettes a single swallow.

Can it be returned? That lost and lusty
Willingness to breathe the heavy air
Liquid in its undulating agony?
But can I, do I, must I always care?

Oh those pillars of Samson's strength
Ravaged a temple destroyed by despair,
Brought down by a god ambivalent,
The bloodied blind man without hair.

Yes, you might say blandly, the moon is cold
And gives the only light that so deeply stains
The distant silence, like secrets never told,
And nothing on that empty world remains.

Your Scent Lingers Like Silence

Your scent lingers like silence
On a secretive tongue.
The violet night, inevitable as a beating heart.
Ponderous pangs of odious isolation
When one so young
Silhouetted on a barge,
Bereft of mooring,
Meandering out of the moon's reflection.
Our kinship sits in the sullen sanctuary of memory
Where bliss was lost in paralysis.
Oh, you must remember. I am sure you remember.
Black as your bounty has become,
Surely you remember the silence,
Long as an empty womb.
We watered for flowers in your barren garden
And searched ardently in that pit-dry stomach
For a semicomatose lust mask mistaken
For a miser's love.
Breathe, breathe that your deep lungs
Like belligerent church bells exhaust the air.
Breathe to affirm the ritual of hope
As angels whisper of despair.

See me in the crimson of a low-hanging moon.
My barking whimpered like a
Wondering dog lost.

Do you see me now? Surely you see me now.
Cataract-cracked as your eyes have become,
Surely you remember the dark whispers,
Dark as an empty womb.
Who is that walking? Is it me?
Hands clasped crablike in expectation,
Words are music with meaning,
Seeds planted in the mind
To flower in the soul.
Words caress your destiny,
Recreate the living and lie with the dead.
The succulence savored and
Sensibilities reborn, the living cinders
promise to be awakened
But for your meticulous reverence for distance.
And of the ignominious ghost that lived
So briefly in illusion and
So long in habit
Of this I jettison
A bottle out to sea.
A message lost but for the currents of time,
An eternity of liquid mystery.
I am left raft-bound, bobbing,
A silhouette, a distraction,
No ballast, no tactile remains,
Not even a protest.
Like a discarded concubine's cadaver.
I am to undulate upon the sea
In moonlight eternally.

The Poet

It is a song that shines
Like garnets on her lips.
How a radiant melody from one who pines
Becomes the sacred wine she sips
And serves our senses from the start,
A vintage that is so rare
It fills both head and heart,
Poured from the soul that she must bare.

Love Poem

Come my love and be with me
As a habitué of ecstasy,
Somnambulating hand in hand
On shaded streets of tamarind.
Oh we are closer than you know
To the tribal horsemen of long ago
That took with passion but lost the dream.
To you I surrender. I am the water in your stream.
Connect me to your fragile frame.
The horseman's heart is seldom tame.

My Life Is Broken Glass

I have spent a lifetime smoothing sharp edges
That invariably no longer fit.
I have spun out a life in doubting as I knit
The question whether we will find all shards and wedges,

Which in their profusion are not transparent.
What is the nature of this broken glass?
Is it the cracks that join in some morass
That makes its splintered state so apparent?

This crippled, jagged puzzle discovered and
Joined somewhat acceptably in place.
Is the bleeding from its remorseless space
From secret slivers and parts left vacant?

My life is broken glass where guilty love casts
Its shadowed doubt, bewildered by remnants
Lost weeping in silent penitence.
Kindness mixed with pain, the present with the past.

And how will it end
And to what end does one reassemble
The puzzle? There is no option but to gamble
If being cannot be without doubt and glass cannot bend.

Awkward is the search for soul,
Sanity in search of reason,
Values in search of treasures not in season,
In search of creation and creator to make one whole.

There is only one conclusion:
Like Sisyphus, a burden then reflection ad infinitum.
Laid to rest and pressed like coal in the dumb
darkness. Yet the days hold me like a well-meaning friend's intrusion.

Memory

Can you blend the thoughts of a single day
And cast them into memory?
Like whispers on the lips of leaves,
They pass through us and tease
Our hearts with longing.
They are spaces in which I can never be,
A dream I am not in.
They yearn to be with me,
Both holy and in sin.

Lingering darkness impedes still
The impatient morning
And its warming
Of the night's chill.

The Bridge

The Filigreed Bridge languished
Like lingerie hung in the silky night air.
The incandescent silhouette
Fragile as the hour
Of one whose last breath visibly melted
Away beyond what is known.
The lace of filigreed illusions mollify memories
Carefully stitched and sewn.

In Memoriam

His words were like a breeze across the meadow,
Filled with violets in moonlit shadow
And eyes that posed the question,
Will there be indelible affection?

What can be done
When winter folds the meadow into memory?
All that we accumulate, both sweet and savory,
Is buried beneath torment and abandon.
When now is past, we learn that now
Is all we have like the drying of a river
Or a final frozen shiver
For a life lost in backward glances.
I am foraging for the answers
To a question never asked,
Never formed by a clarity about the present or the past,
And what of this affection, like a stray
Cat rubbing on one's leg or like the day
Growing warmer as the sun rises,
Until the cool blindness of night excises
The song of his breath and stills its flow?
What insidious fate wills it so?

II

In nature, a venom has been devised
To take me on this cursed ride
Upon the boat that Charon built
For the lies that hide beneath the guilt.
What of the flesh that putrefies
In hollow sockets that were the eyes
Of one who could see a soul?

If each and every soul
Is but a flake of snow
Ten million cries are silenced in the melting afterglow.

III

A bitter taste lingers beneath one's resignation,
Like serving her morning coffee
Or that kiss good-bye after a hint of hesitation
Or listening to the lamentations
That are the banal platitudes of
Pious monks or rabbis, as the case may be,
With eyes lifted to the sky
Reporting to an unseen mystery,
They say "God only knows."
But that is but a pose.

IV

I have stretched my understanding
Beyond calculated care
And acknowledged the minds meandering
Of those who could be there
In "the hour of greatest need."
Why is it they are here?
They cannot change the deed
(as if one could plant another seed).
No, when the mulling and platitudes are soon
Exhausted, emptiness will once more fill the room.
Then upon the blue blanket of moonlit glow,
I too one starry night will cross the meadow.

The Hanging

With ease,
 my love,
The gallows found the evening breeze.
The bells applaud the falling sun
As older women
 In their desire to be desired
Crack ruby lips and
Sigh, "What's done is done."
See you,
 my love.
They go, their arms entwined,
And share the moment while they weep.
Beneath a wilting sun,
The shadows fettered to their feet,
They lick their memories, if you will,
Under bony branches.
Soon the dark and chill.
It is time,
 my love,
For the pounding pulse to still.
The boulevards turn to winding streets
With comfort in sequestered corners
Where supper is set for sacred mourners.
They eat their berries, wine, and bread.
The light goes out, and there in bed
The day that lingered on their lips
Soon lost in dreamers' yearning hips.

Home of an Artist

Among the wild winds that pursue the leaves,
Memory sings a half-lost melody
As the fertile ground beneath me heaves
And returns me to the sanctity
Of the only home that I have known.
The words and pictures distilled within,
Beneath their tutelage I have grown.
For in these halls and rooms, I find my kin.
What children born of image and of word
Are hearth and comfort, love and proof,
One's existence a mirror of the truth.

Lone Wolf

I am a wanderer beyond the herd.
A wolf alone in solemn isolation
Or the waddling of a flightless bird
Or a faceless briefcase at the station.
All the sheep's heads are bent,
Tearing at the roots for their sustenance.
Nibbling daintily, oblivious to the scent
Just beyond their obedience.
All white as if in uniform,
A life in constant rhythm.
From chew to chore, every step is known.
Will they arise to find the schism?
Mine are the habits of a malcontent.
Empty tongues wag more than tails.
I have enough to pay the rent,
And nibbling no longer has appeal.
Shall I board the train?
It does not matter to where. I am content
To wander in the rain
As my eyes witness the evening's firmament.
Will you come with me?
We can talk of many things
And have a bit of company.
We might witness miracles with wings
And share the bounty of our hearts and eyes.
It is these things of which I fantasize.

In Praise of Words

What is the wonder of words when
Filled like a balloon with
The hot air of husbandry?
A hummingbird orgasmic
In a naked flower.
Words are windows open
To the day
And night's insidious dagger.
They can live fearless and feline,
Ferocious even in a whisper.
Words are a lion's song in a proud father's throat.
Words will cherish our existence
When we but for them have vanished.
And they are the masters of the song,
Each sound scented and flavored,
Bending hard men to their rhythms.
When their spirit girds the weak,
Empires have risen.
There are the words that fill the heart
With heaven's power.
They can bleed the unseen spirit,
Gazing, eyeless
Like the hunter's fallen deer.
Like us, they are mute in isolation
And covetous of that
Which can inflame the soul.

Wrapped around a cause,
Attach us to a harness and a plow.
They harvest our souls and our ashes.
Oh words
In an infant's hand
Grow and grope
With the wonder and confusion
Of windswept snow.

So Silent Is the Snow

So silent is the snow
Though footsteps cracked the ground,
Alert appears the doe
to the tracking of the hound.

Shall we choose the angst of love
Or the escape of happiness?
Gun finger in the hunter's glove,
The deer so close to the abyss.

In another venue and of another vein
The world scorched with violence
The moment cruel with rain
A slave scared by obedience

Bent, his bare back revealed
A spine like links of chain.
Bent, his bare back revealed that we are his brother Cain.

Winter

Winter does not want to end.
Its long and callous glow,
Black trunks and green grass
Smothered in the snow.
Gray is the pallor of those who stayed too long,
Who hobble broken,
Waiting, waiting to embrace the warm
like an angry dog's hot teeth beneath his cold jaw.
But all seasons come and end, shrivel or withdraw.
The child straightens as the mother bends,
And the dog has teeth no more.

Time

When winds blow over the land
To carry time across the dusty sand
The salty breeze brings memories
Sliding into nostrils silently
And with its touch, like a hand
Strokes the sea.
Then our hearts are one, or so you say.
Yet is that not a lost and distant memory?
The young see not the past
The old by it caressed
Lost without a future plan
Beaches filling hours with sand.
Waiting for my head to bow
My back to curve that I would bend so low
To see only the eternity of sand
And canes to hold me in each hand
And canes to hold me in each hand.

Dark Companion

I am your reverie
As trees dancing in the wind.
I am the memory
Of cold moonlight upon your skin.
I press so gently upon your lips
To catch your quivering fire
And cool the blood of your wounds that drip
As rhythms of days and months conspire
To meet you in your tomb,
To hold you as my prize,
To drag you through my unquenchable gloom.
For mine is the wicked, the dumb, and the wise.
Now you must know me.
I, from the beginning never left your side.
Did you wish to ignore what we
Both know? From me you can never hide.

The Round-Bottomed Babies

The round-bottomed babies' puckered lips
Curled and cooed before the apocalypse.
Compare their ample limbs
To the hollow stare of empty dreams
With bulbous bellies begging for more
In the sandy dust of distant Darfur.

Your Words

I

Your words are the milk upon her lips.
There is milk in the lust you feel.
The milk is the desire she sips.
With a heaving fire you seal
Her succulent, milky hips.

II

As the bare, bulbous expression
Of one's passion nippled and
Crimson like the dawn
Begs for the sunlit burst,
The apex of the storm,
The quenching of her thirst.

The Artist

Heaven whispers hell screams.
Who are the lovers of fire?
Who lives inside their dreams?
Who inside their desire?
What artist does not know this curse
Woven on seduction's loom?
Gods extol the universe.
Death deepens nature's bloom.

Dissolving in the Shallow Mist

Like a dream's silent song,
The bridge fell beneath the fog,
Dissolving in the shallow mist
On snowy breath that kissed
The melting night,
Cold hunger devouring all in sight.
The world has come to this. That shallow
Air where only the blind inherit majesty,
Where all that is consumed leaves us hollow
And swept into the vagaries,
Like gasping in a vacuum
Into the gaping mouth of doom.
What sanctuary can one find?
Weeping drops fall beneath the morning sun
To find the one, the only one,
A melted gray memory,
Now smoke in the chimney
Before the pale, drizzled fog.
Time has splintered and made us fragile and frayed.
We, like antelope, are chased by a hungry dog.
We have no prayer but continue to pray.

Ruminations

Dawn peeks over the buttered sky
When heaven alone will mock
The progress of his clock.
His ill-kept ruminations
Lost like antiquities beneath a thousand whys
In lightning years gone by,
Lost somewhere on the orbiting earth,
Blinded by sorrow, a dearth
Of tomorrows for yesterday's sins.
Again the day begins.

A Flicker in the Universe

And I like the night sky
Have only eternity.
There is perhaps a why
That eclipsed I cannot see.
If infinite silence is our destiny,
A flicker in the universe
Beyond joy and ecstasy,
Beyond nightmare or curse,
No matter, it will come.
One cannot rip
The rider from his horse
Or the ocean from its tide
Or the moon from its course.
There is no place to hide.
These are the words of one's decay.
One need not be a Pharisee or sage.
A dark light descends upon the day,
A moment's song sung on a fleeting stage.

New York

Do you hear the bellow
When the ramrods hammer,
Hurls its taxi's yellow
Down its avenues and streets
Like petals torn asunder,
Amidst the asphalt's blackened thunder,
Its towers like cathedrals,
With occupants numerous as rain,
Built for singing their madrigals,
Mission of monetary gain
This music may hold all humanity
To our ultimate calamity.
I cannot say exactly why or how
It became so unattached from
A dreamer's search for the mystery of now
Or dreams of places and times that may never come.
One can only hope and sometimes pray
That in its beating heart resides our humanity.
But maybe these are judgmental rants,
The hum of this hive, its energy,
Its power, even arrogance.
This city, like a king, also has its majesty.
As I see the sun reflected on its steely face,
I yield, seduced by its embrace.

This World

I

This world that often speaks to me
About little things and eternity,
From leaves to seasons and those in prayer,
From wind's breath children to aged despair.

This world that often speaks to me
Whispers darkly of rotted woodlands, of rusted factories,
A flightless bird engorged with maggots here,
Upon her ravaged belly one prancing, youthful mare.

This world that often speaks to me
As the hungry search for spirituality
When conversing over lunch (the soup is only fair),
A lifted brow, a sigh (you know how much we care).

This world that often speaks to me
As I bow with due respect to our mortality,
And who or what was I to emulate
Before my youth would dissipate?

II

The key is that one's fantasy
Marks the light that is one's heart.
To wither without its ecstasy
Is the wilting of great art,
For the hand of nature permeates
And twists what we will.
It tosses darkness beyond our spate
And makes the torrent still.
One life so lived with sweetness grows,
Though the lost and empty find a way.
For true artists, the child is our muse.
His death for others, the price they pay.
I think it is not for us to choose,
Yet when the damaged hollow of my heart's
Whispered vapors tells the story of my art,
When almond flowers dot the sky,
Orphaned feelings struggle like Jacob to tie
The rhapsody to ground and air.
Yet, was I, am I wholly there?
Never was my art holy so
That I did not have to bow to Fra Angelico.

III

With breath on cold ground,
My urine speaks.
I hear the drummer's muffled sound
As it weeps.

As it thumps a steady beat,
Like horses riding from the past,
The bone-dry earth beneath my feet
Consumes in rain the entire past.

The soldiers, artists, and the priests
Lie here with potatoes and beasts.
Gone is their malingering fear
Of the creatures who upon them feast.

Recollection

What are the connections of long ago?
The synagogantuan world of a Jewish child
Seeing recollections
Through frozen rivers underflow
Or yellow papers in a forgotten file.

A small and solemn world was his,
Cavernous, colicky soul.
With ambition to comfort a lonely god,
A spirit sang in silent bliss,
Made that small boy feel whole.
Sanctity filled with gratitude
Gave him the sanctuary's paternal care.
Oblivious blizzards melting snow,
Apricot autumn's falling leaves,
Or the summer flame that disappears
Behind the wilted flower's glow
Of the countless numbing years.

Swollen Clouds

Swollen clouds beneath the azure skies
Remind me of a past gone bye,
When I was swollen full with rage,
Puffed and pompous, a bellowing sage.
My "majestic" advice was for all fools with
Filigreed tongues lashed with lace scythes.
I, the bludgeon-tongued with perfect arrow,
Headed headlong toward the only sparrow.
Of course, what else could
I do? For I was fire; all else was wood.
I scorched the green earth with my brazen
Youth. Now swollen and cold below the frozen
Azure blue above my now bent
Head, far from the prickly thoughts that sent
Me here. Far from the mockery of knowledge.
The unforgiving thorns splatter the crown's edge
That bites so deeply the souls of fools
Who bow to see their visage, clear in pools,
Beneath cadaverous and numb steps toward
An eternity of soulless words.
Yet as I see my grayed reflection
Clearly, there must be made a correction.
For I am no longer sure who I am.
I am no sightless Oedipus. I am
Nothing now of that myth I created.
No myth in fire was consecrated.
Beneath the swollen clouds and winds that fan
The azure sky, I made no footprints on the land.

Homeless

This man, prayerless and homeless, confounded
By the repulsive stench that repels love.
To live what is left of life, longing
For so little to fill the empty
And shredded plastic bags belonging
To a dream beyond redemption, aimlessly,
For no particular reason, no sign of remission.
To raise his head to see beyond the endless road, pondering
The hunger that howls for a benevolent touch,
Alone but for the eyes that feign blindness, watch
In warmth and comfort.
 How will she atone?
Are you there? Is anybody there?
Amidst the noisy chatter, putting on
Her lipstick and touching up her hair,
She says, "It is no matter. There is nothing to be done."
There is nothing to be done to fill
The hole dug deep
In the eyes of one who would not weep,
For she who is like him but for happenstance.
"Oh, the music started. Would you care to dance?"
Morning wakes the blind and the belligerent
And those in search of bastions of beneficence
To find the wise, the wicked, and the innocent,
Exhuming their rising corpses, relinquishing their excrement.
And so it begins again,
The hollow harboring of habits to rule the day.
 "Just one more dance. Won't you stay?"

Calling of an Artist

When the great river that is my calling
Drank me from the ancient well,
Drawn to earth, a spiral falling
With broken wings descend to hell.
To see the vanity of fragrant flowers,
To feel the parsimony of judgment,
Every day a judgment day.
The isolation in our towers,
The hallowed space in which we pray,
The spirits that one must see
When torrents of night set free
The sullen bird of ecstasy.

River, New Hampshire

As I sit upon the shore
And watch the river flow
To the sea,
Its crystal light is more than what I know
Of eternity.
The dark roots of trees that cling
To the river's edge
Know far more
The song the waters sing.
Roots that grasp her edge,
Dear the life that they are holding for.
A boat glides so still,
As if there were no time
Beyond my history.
When here, I have no will
Nor need for one
To guide me.

When the Darkness Breathes

When the darkness breathes
Upon my skin
And whispers of a gentle freedom,
The moon walks with me
And gathers on the lake
Like jagged glass.
Behind the bare fingers
Of solemn trees and silken grass,
Oh mystery, you are not what you used to be.
There is the peace of a cadaver
In the night-air chill.
All that should be there
Is weighted by the past and fills the heart.
A gentle pat
On the shoulder of a boy.
Oh mystery, your stealth is like a cat.
The heart is a haven
For healing and for hurts.
It is a reservoir of pain
When a child visits the darkness,
Knowing for the first time how vast his isolation,
Knowing the endless night of loneliness and longing,
Vulnerable to the beast in the closet,
Knowing without question
The impotence of little fists
In a silence shattered by tears.
Oh mystery, you are not what you promised me.

Give Breath to Your Soul

Give breath to your soul. It cries to exhale.
Hollow bones buried in sand should not be your progeny.
The light of joy on winds will sail

As forests kiss the sky and waves caress the sea.
No reason, no why, only you alone with eternity.
Give breath to your soul. It cries to exhale.

A heart is meant for mystery,
Like a moonlit shadow cast through a stoic tree.
The light of joy on winds will sail.

Learn from the heat that feeds the sun, the queen that births the bee,
And all the heralds' songs a hallowed ecstasy.
Give breath to your soul. It cries to exhale.

Oh, there is sadness and much pain to see.
It is this contrast that made a believer of me.
The light of joy on winds will sail.

And when you can see the end of your journey
Filled with the riches of dreams and memory,
Give breath to your soul. It cries to exhale.
The light of joy on winds will sail.

Fatherly Love

See now your heaven is on fire,
Your world a-glow, a vision to inspire.
Oh how a father loves his son.
He is a king, and you his kingdom.
Yet what is done is done.
No child sees oblivion.

A Moment's Cruelty

Must I, stained by her belligerent melancholy,
Shattered into the porcelain shards of her deceit,
Be even so respectful as she sullies
With words my soul like nails through my hands and feet?

A scent of ritual suspended on the wilted air
Requires that a bitter tongue
Disperse the cruelties that one must bear
As I await the return of the pendulum
And breathe deeply the fragrance of her hair.

Have You a Reason?

Have you a reason to block the sun?
It lives that you may breathe.
Is there not room for everyone?

If by it you are nurtured warm, then you have won,
A light so bright you can't conceive.
Have you a reason to block the sun?

About my death, what's done is done.
There is nothing of this carcass to retrieve.
Is there not room for everyone?

Faux piety and fruit made rotten
By the inquisitors, soiled the rabbi's sleeve.
Have you a reason to block the sun?

So gather all, as if as one,
As the weft is to the weave.
Is there not room for everyone?

See the blood that pours from the forgotten
As the bells of belligerence peal and heave.
Have you a reason to block the sun?
Is there not room for everyone?

Like an Embryo

It is the prayer
That, like an embryo,
Evolves into despair
To see how far one can go.

That like an embryo
Before your empty dreams.
Just how far can you go?
Empty dreams evolve and grow like ripples in a stream.

Before your empty dreams,
Like an ill-formed embryo,
Empty dreams evolve and grow like ripples in a stream.
What will become of you? You are so

Like an ill-formed embryo,
Lost, seeking what is false or true.
What will become of you? You are so
Full of the blood in your veins that flow,

Lost, seeking what is false or true
To make it live, this embryo,
Full of the blood in your veins that flow.
An embryo is a curious thing we cannot know.

To make it live, this embryo,
It grows with stealth like the birth of spring.
An embryo is a curious thing we cannot know.
Insidious and insincere whether from a serf or of a king.

It grows with stealth like the birth of spring.
Imbedded with hope and fear in the womb and the tomb
Are insidious and insincere whether from a serf or of a king,
Yet it is this that is our home.

Imbedded with hope and fear in the womb and the tomb,
From that speck of an embryo,
It is this that is our home,
And it is this that is our prayer.

Do You Remember Me?

Do you remember me?

I walked you through your infancy,
When fragile like a leaf,
When God bestowed belief.
How miracles can come,
For now I have two sons.

Do you remember me?

Upon the fantasy of time,
When I was in a world that would
Overwhelm with gratitude,
Invited to witness
And a tool to introduce the countless
Wonders in joyous harmony.

Do you remember me?

How tall and wise from such a little leaf
That nurtured by love has grown beyond belief.
This pride that burst my heart with tears,
To have these sons so many years,
Who may have their own progeny,
And perhaps to them they will remember me.

Upon Her Father's Passing

The descent is steep and ends with the stillness of the air
That no longer whispers.
The wheezing song heard
Asks, are we but passengers on a prayer?
Were we even there?
That most real beyond our grasp,
Beyond our senses,
Our sensual longing for the mystery to emerge.
A Vatican flagellant to appear,
Ripe with the welts of overwhelming sorrow.
The inevitable question:
Am I the husband of this sorrow?
And am I the cause of the inevitable?
If reason be, then am I not, then, the reason?
As he descends beneath the flame of the silken grass,
Am I not, then, the reason?

VISIONS

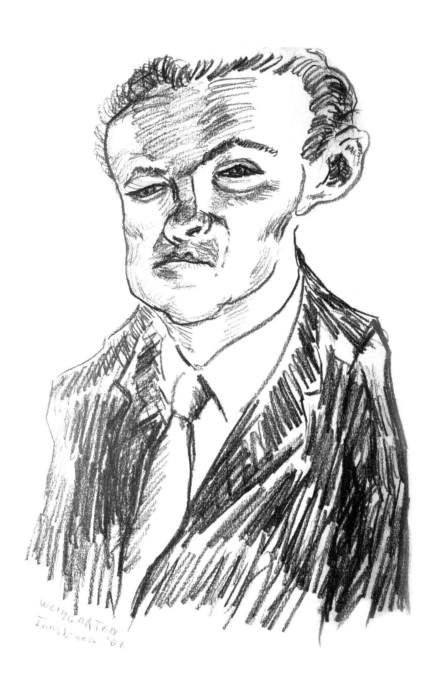

WEINGARTEN
Innsbruck '06

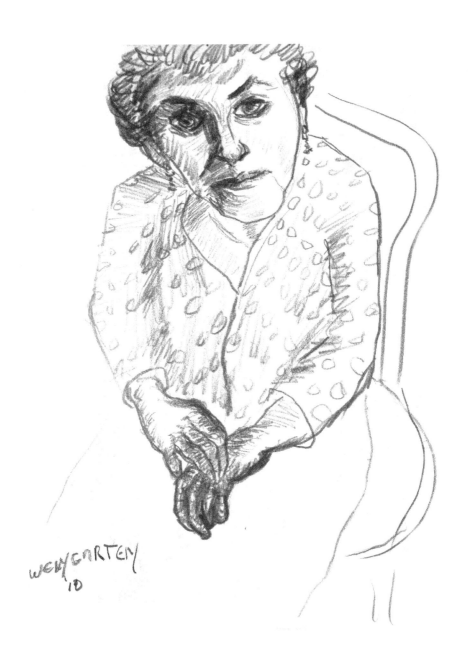

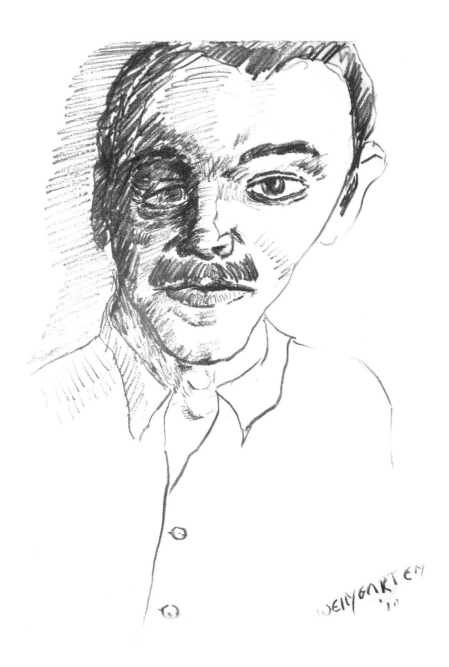

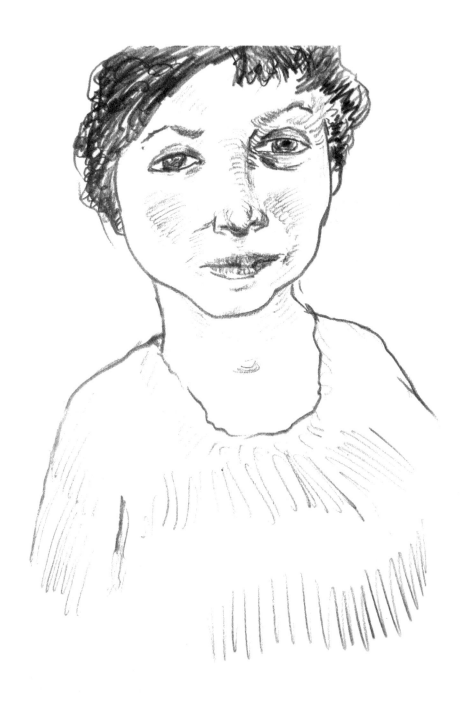

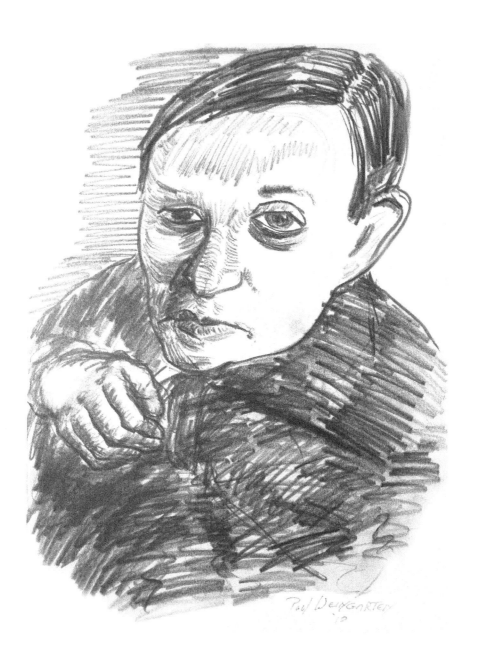

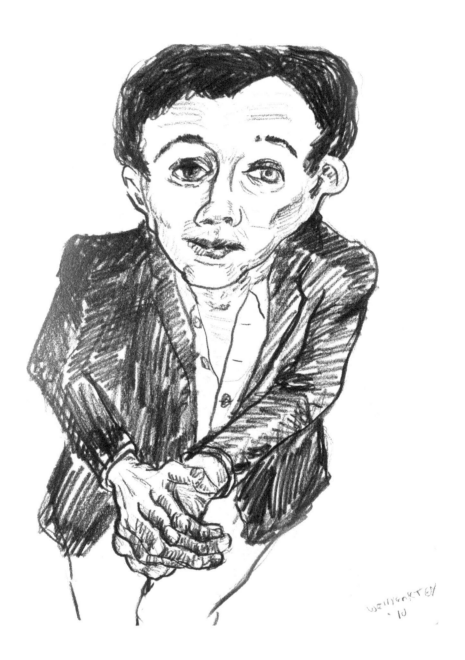

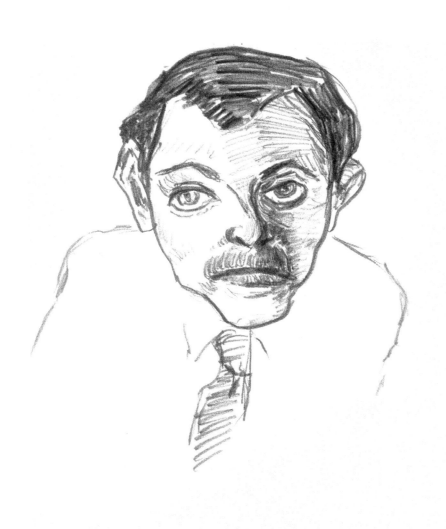

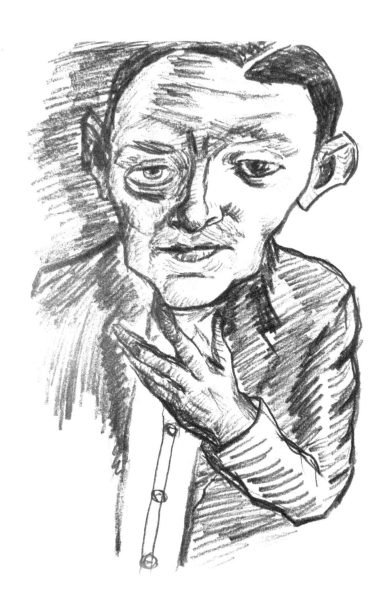

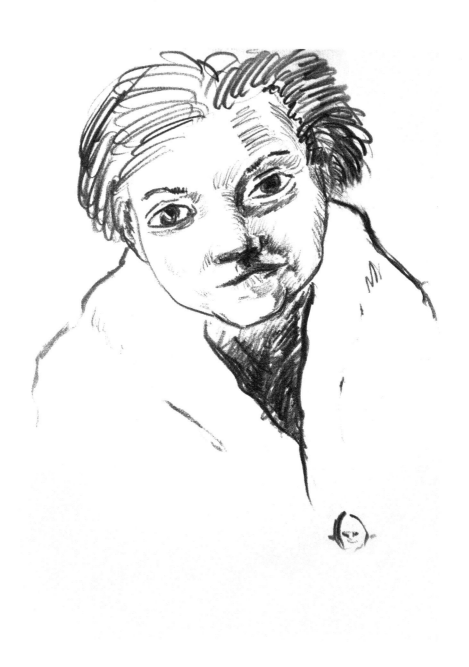

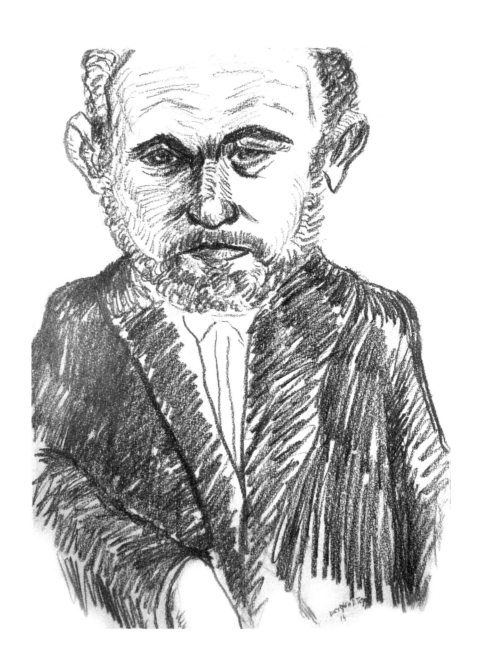

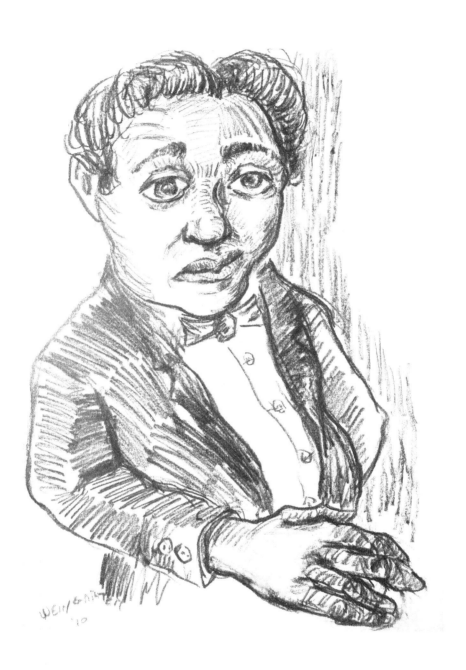

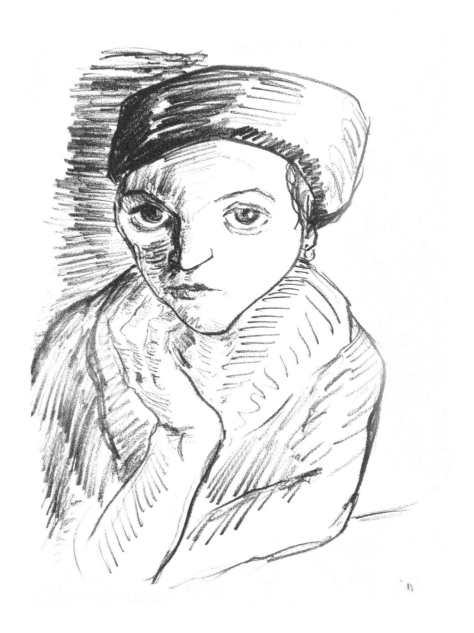

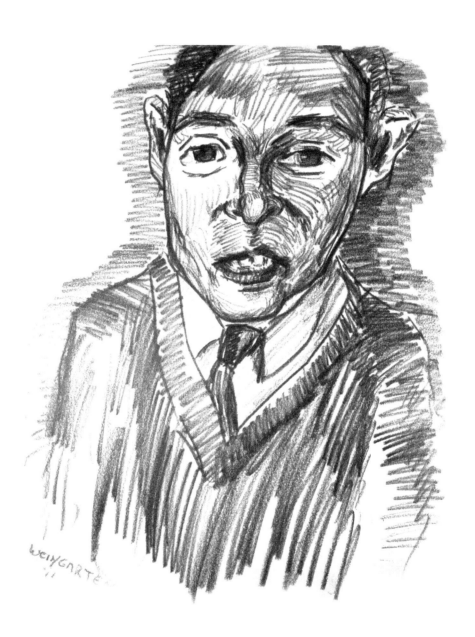

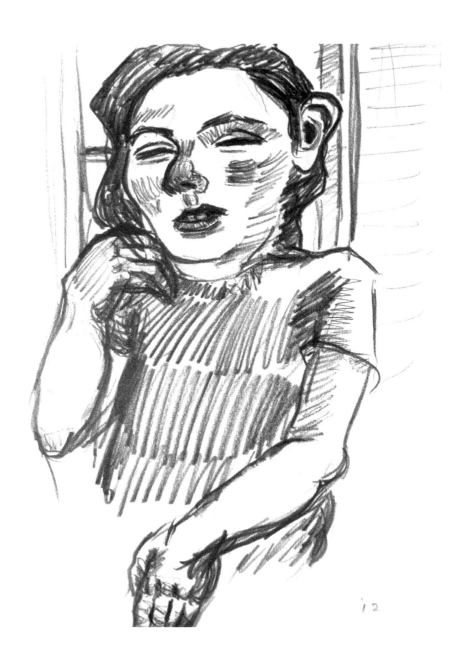

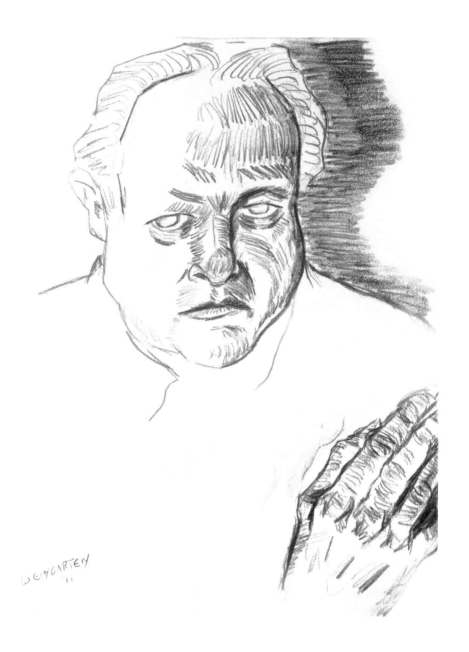

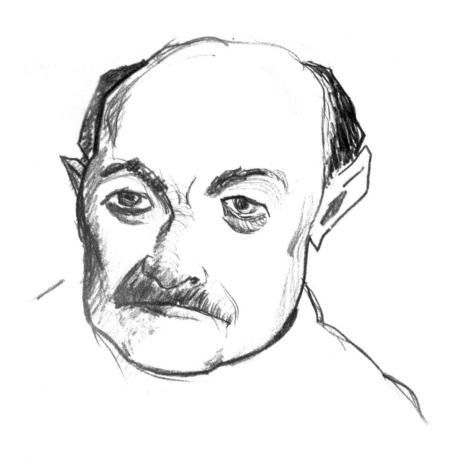

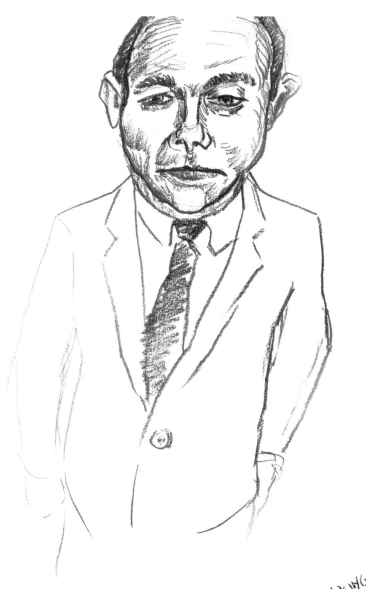

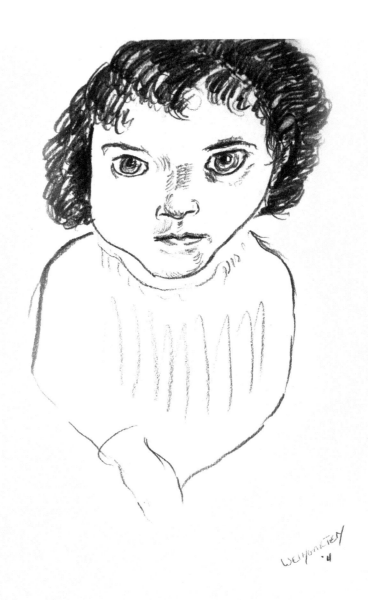

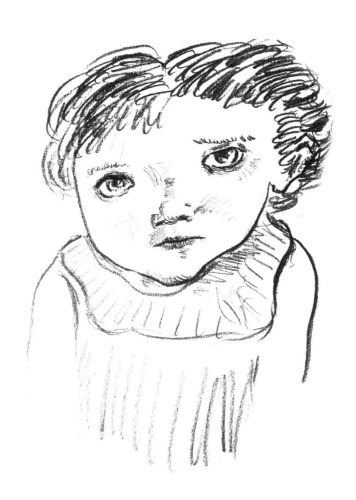

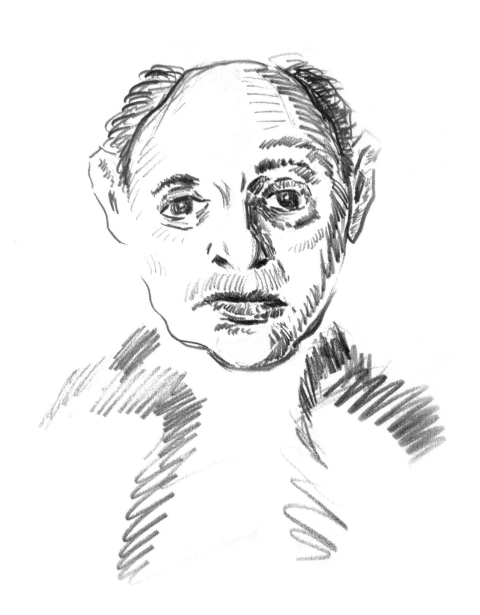

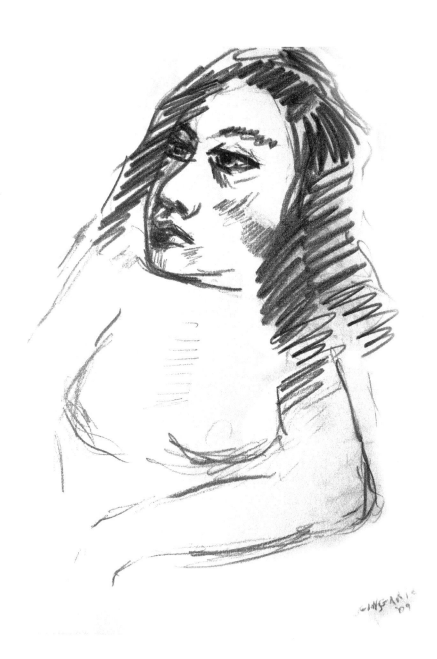

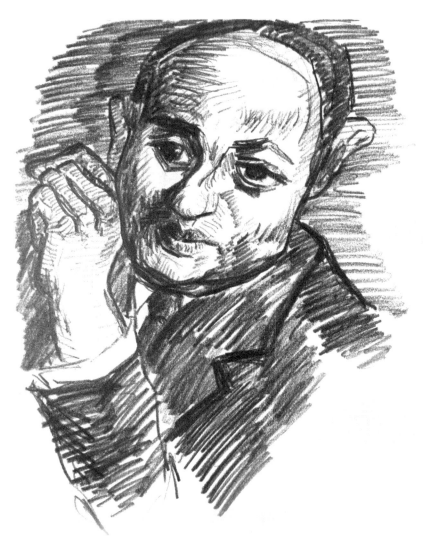

'12

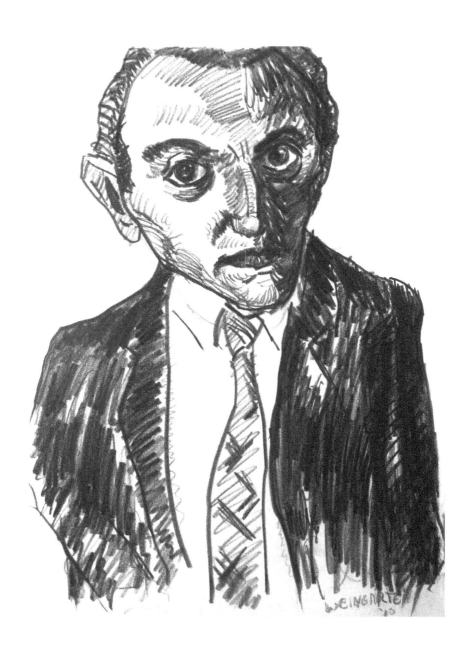

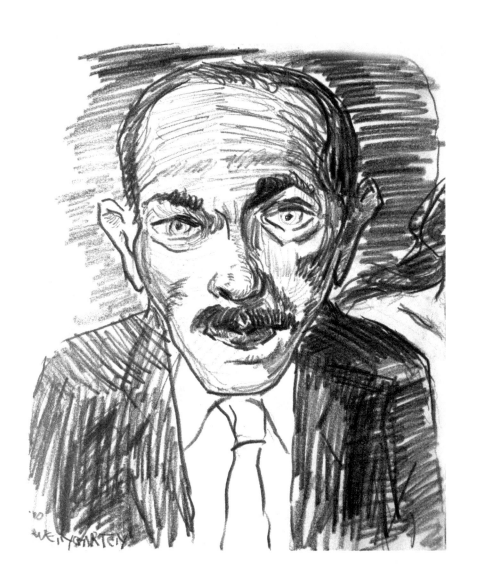

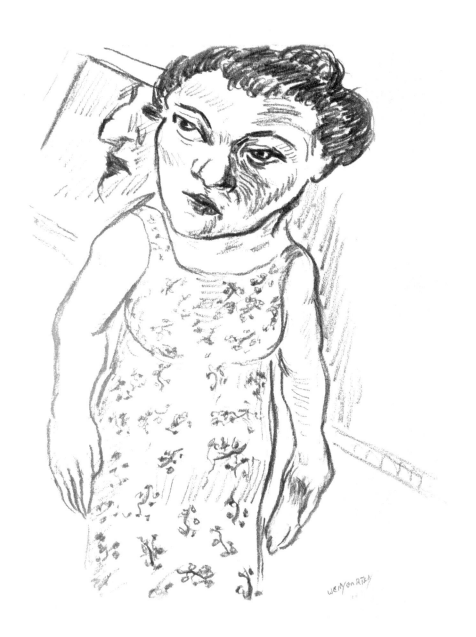

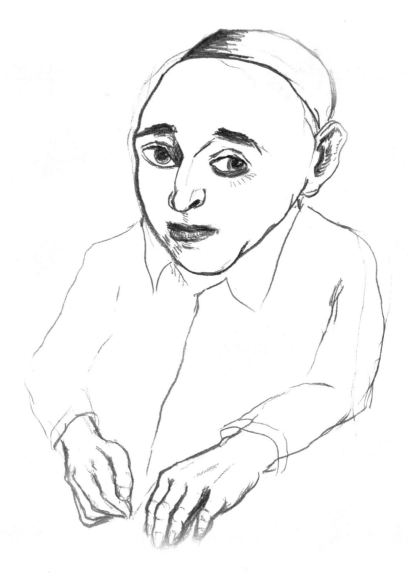

Weingarten
14

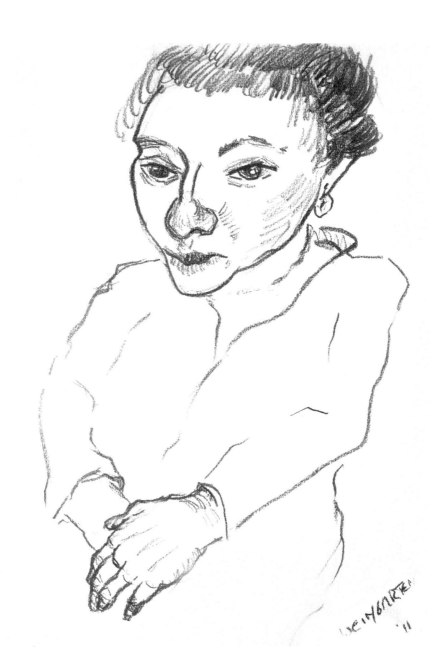

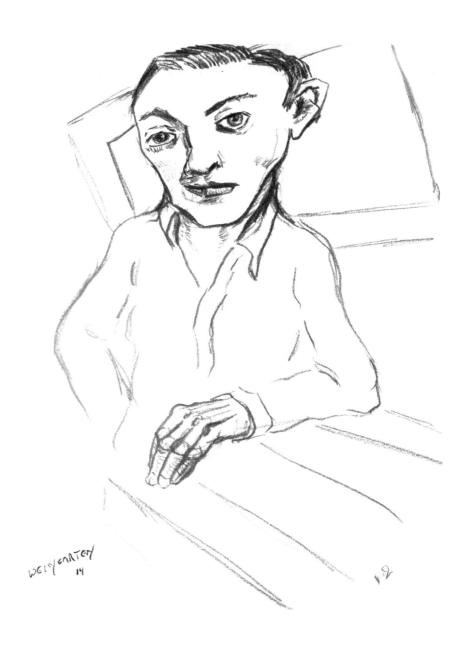

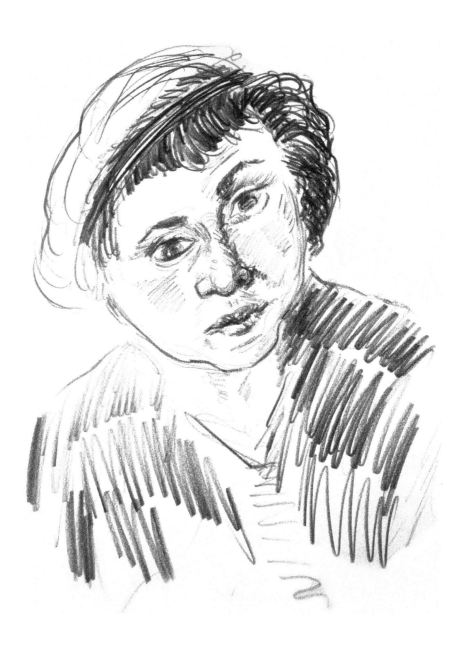

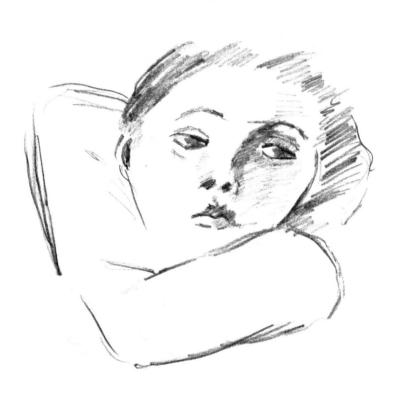

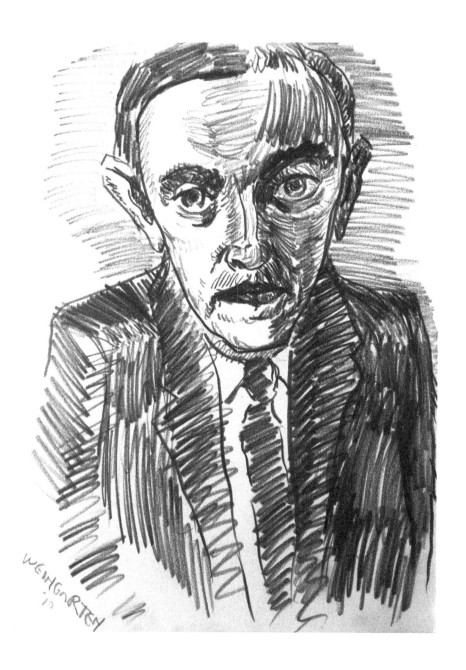

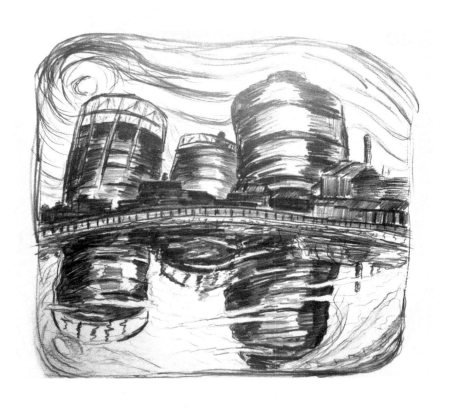

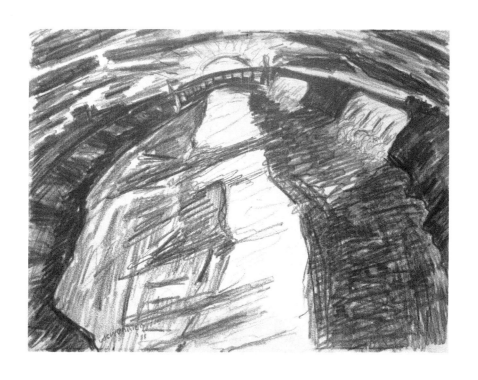

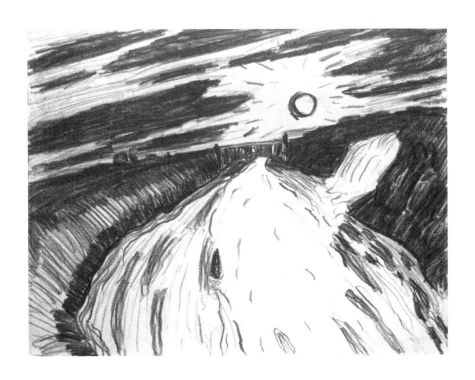

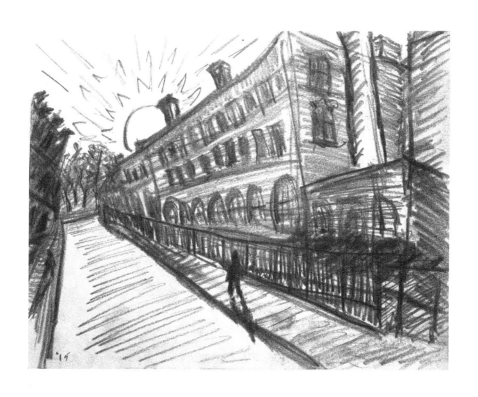

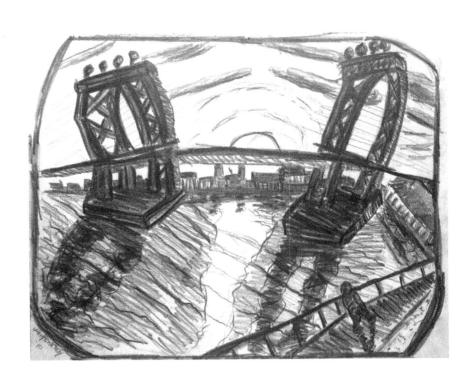

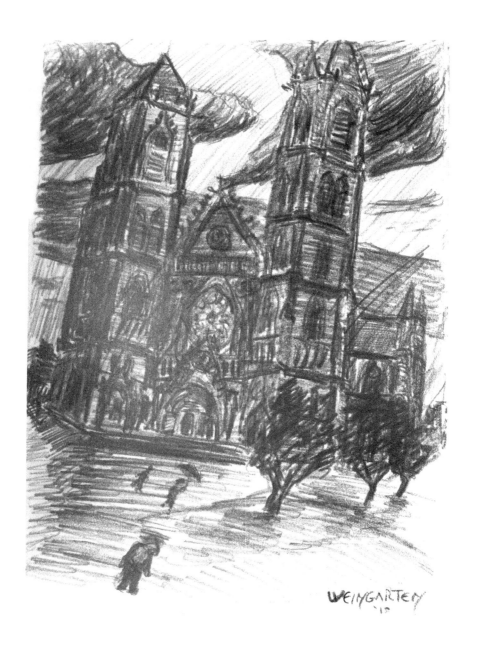

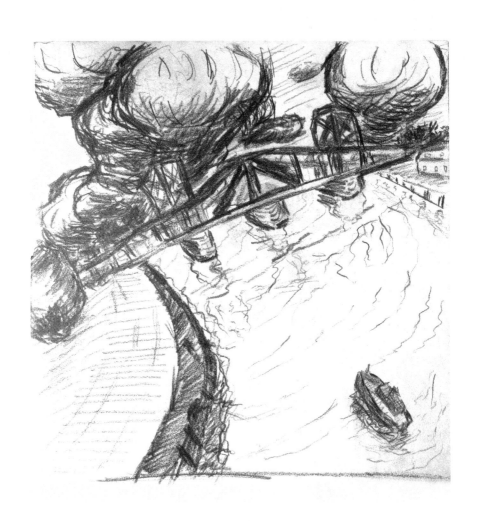

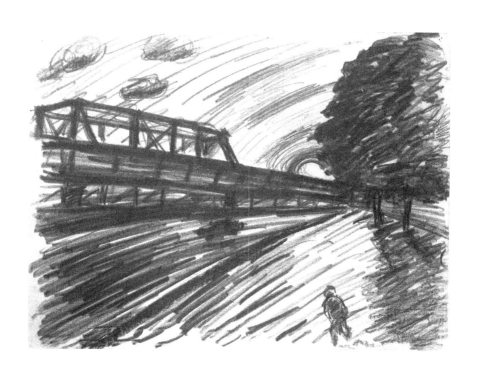

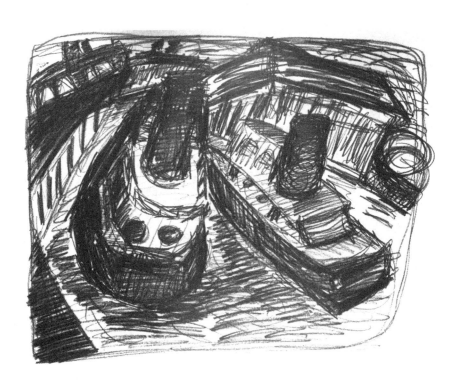

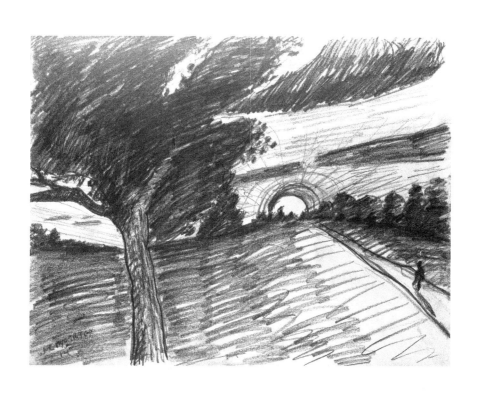

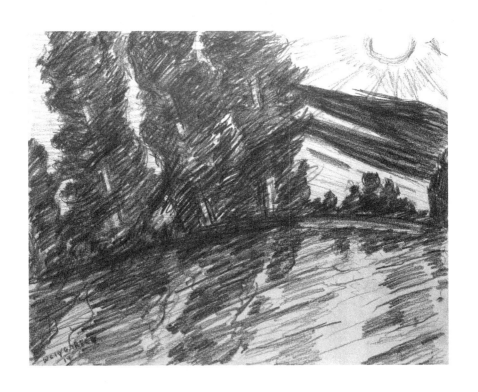

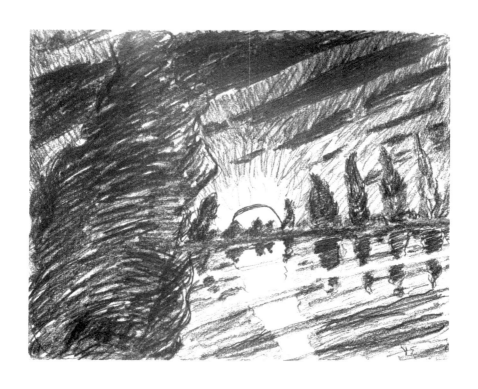

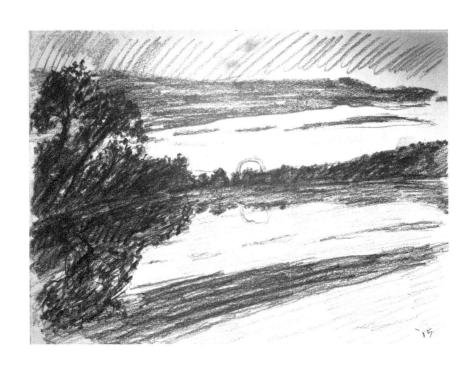

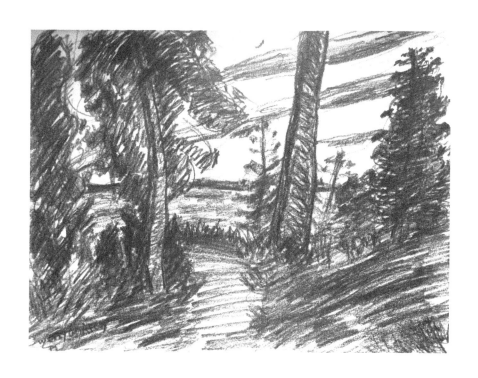

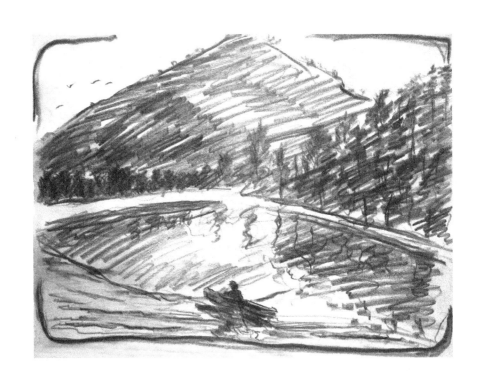

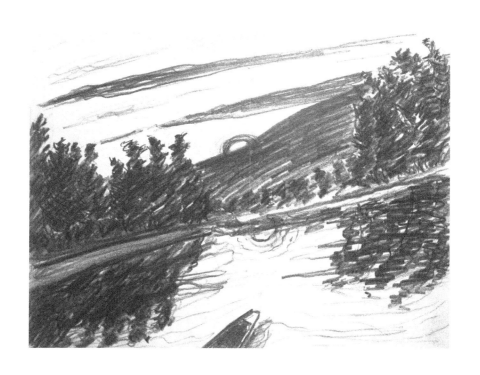

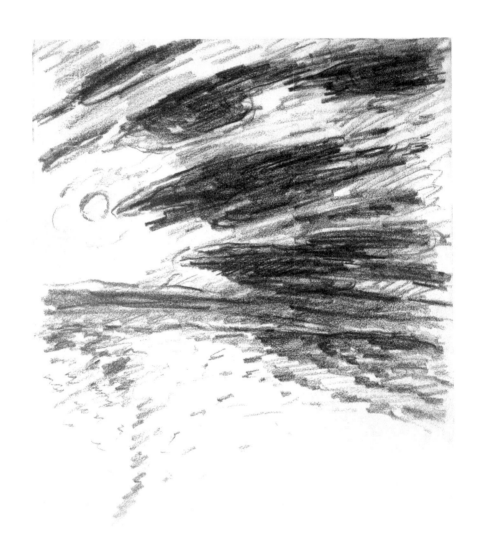

Printed in the United States
By Bookmasters